SUNKAWAKAN WASTE THE HORSE IS GOOD ألْخَيْل ألْجِيد

Viggo Mortensen

PERCEVAL PRESS

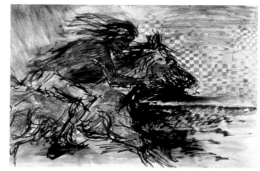

Tasunke Witko (detail), 1986

THE HORSE IS GOOD

ISBN 0-9747078-3-X
© 2004 Perceval Press
© 2004 All images Viggo Mortensen

First Edition
Originally published in paperback in 2003.

Published by Perceval Press
1223 Wilshire Blvd., Suite F
Santa Monica, CA 90403
www.percevalpress.com

Editors: Pilar Perez and Viggo Mortensen
Design: Michele Perez
Copy Editor: Sherri Schottlaender
Digital Print Mastering: Hugh Milstein, Digital Fusion

Printed in Spain at Jomagar, S/A
Distributed to the book trade by Publishers Group West

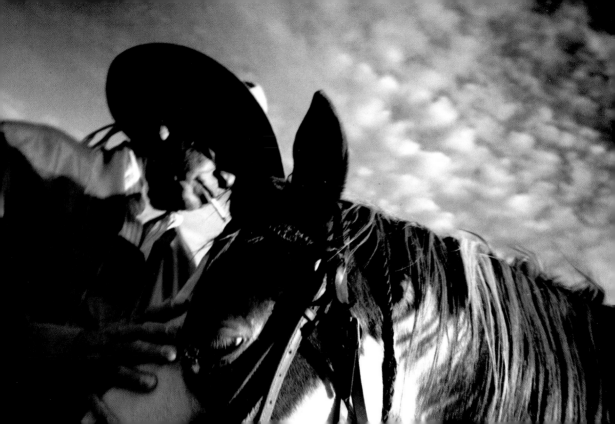

FOR HIDALGO AND FRANK T. HOPKINS

Thank you Lockie

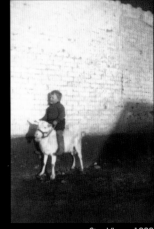

Stor Viggo, 1932

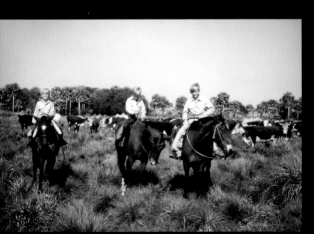

Walter, Charles, Lille Viggo, 1970

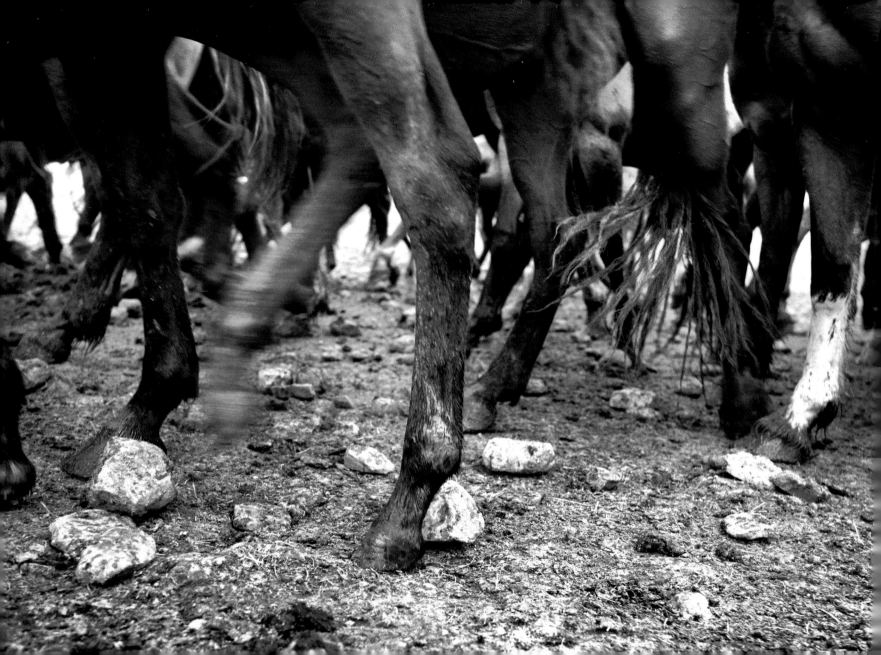

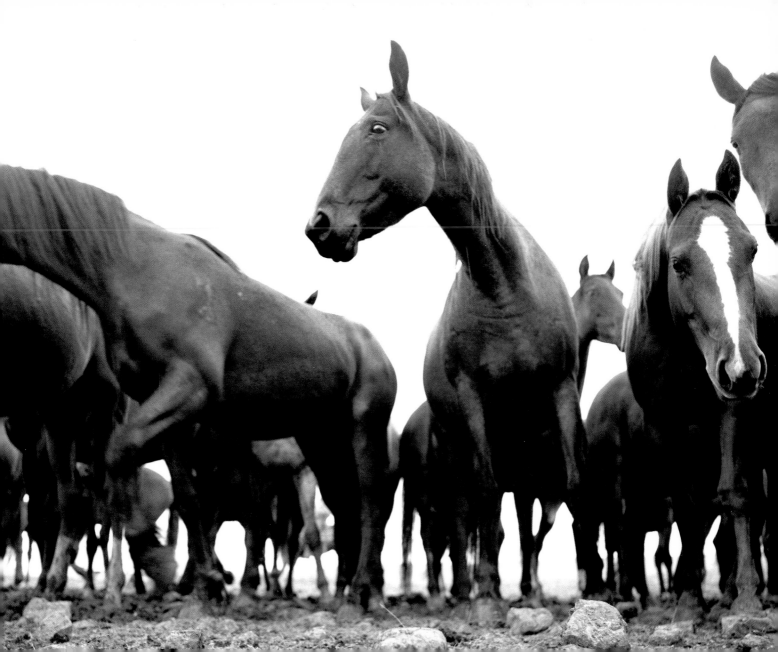

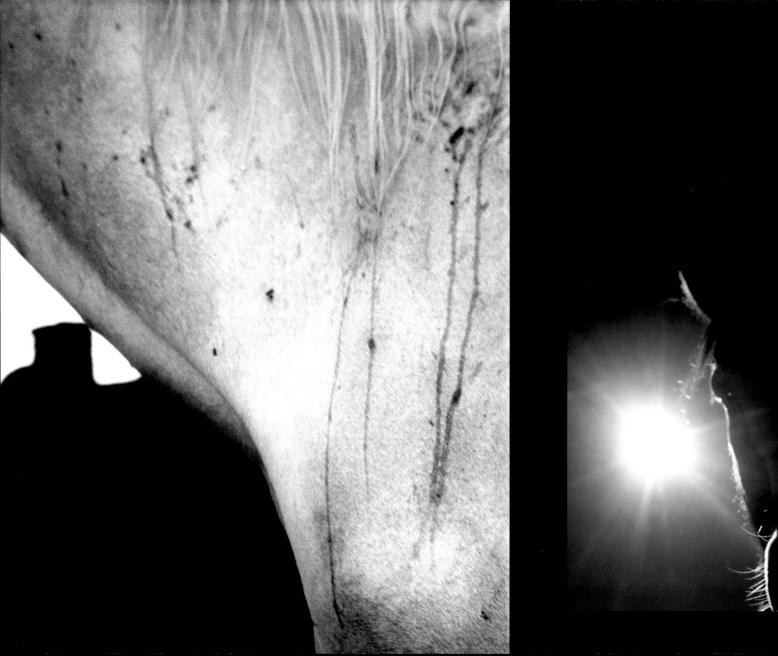

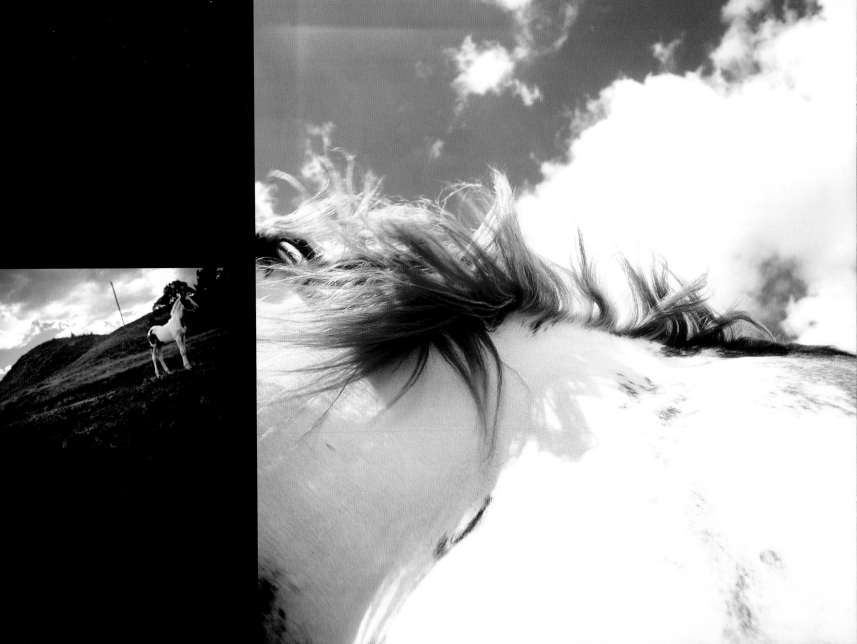

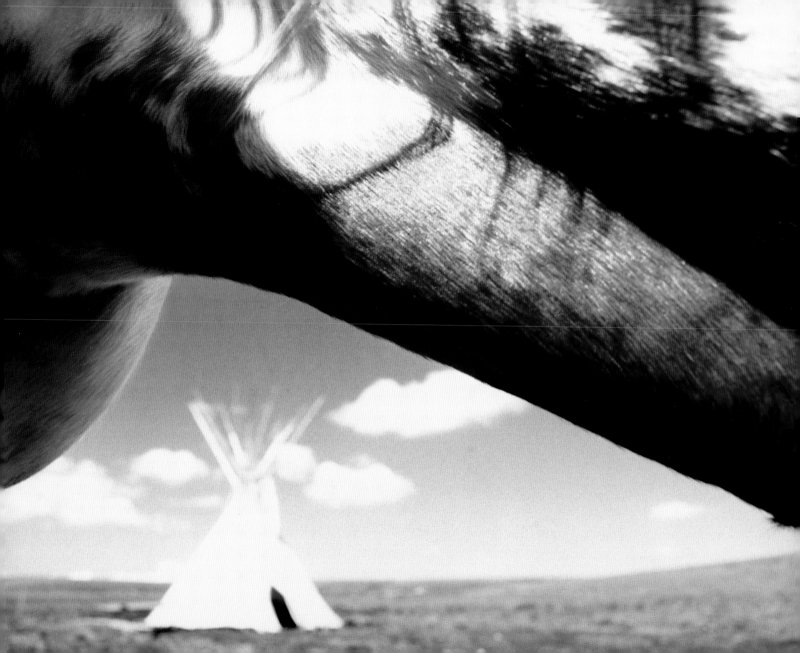

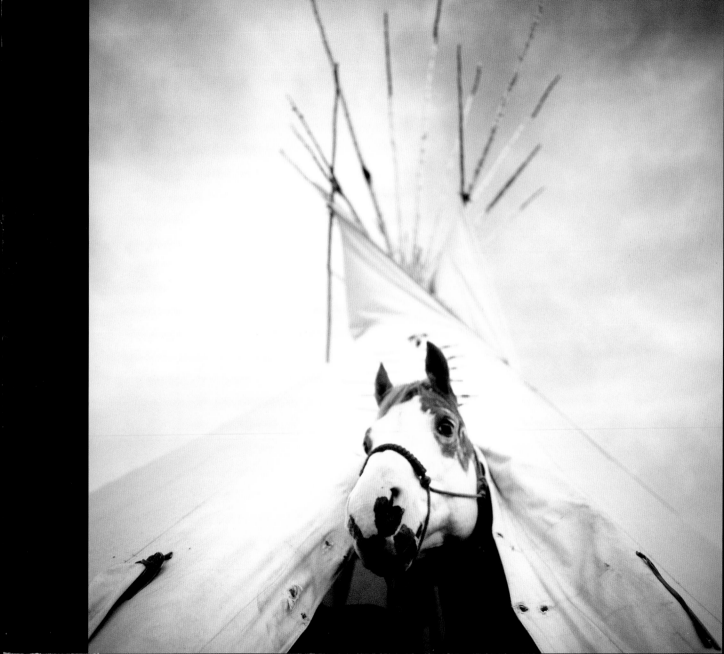

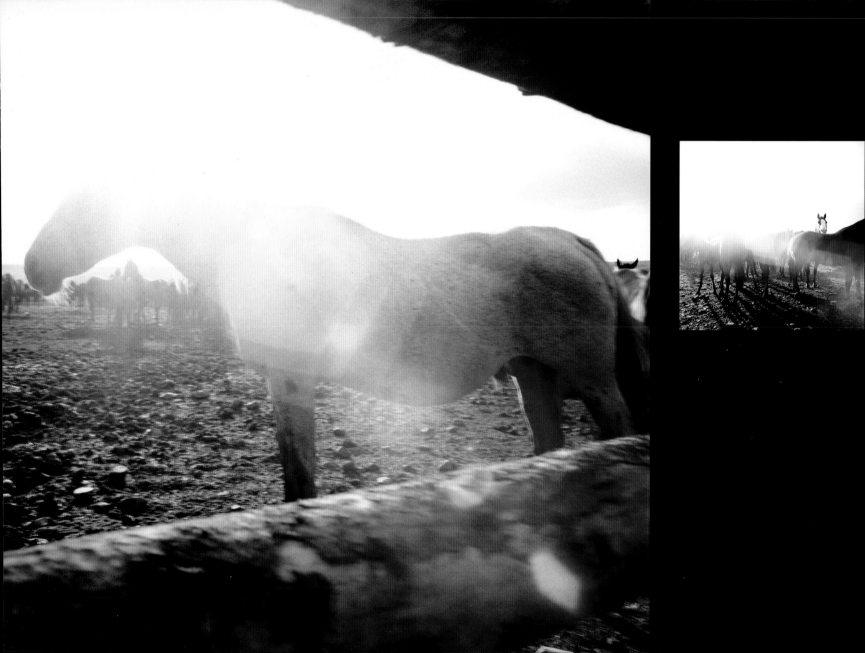

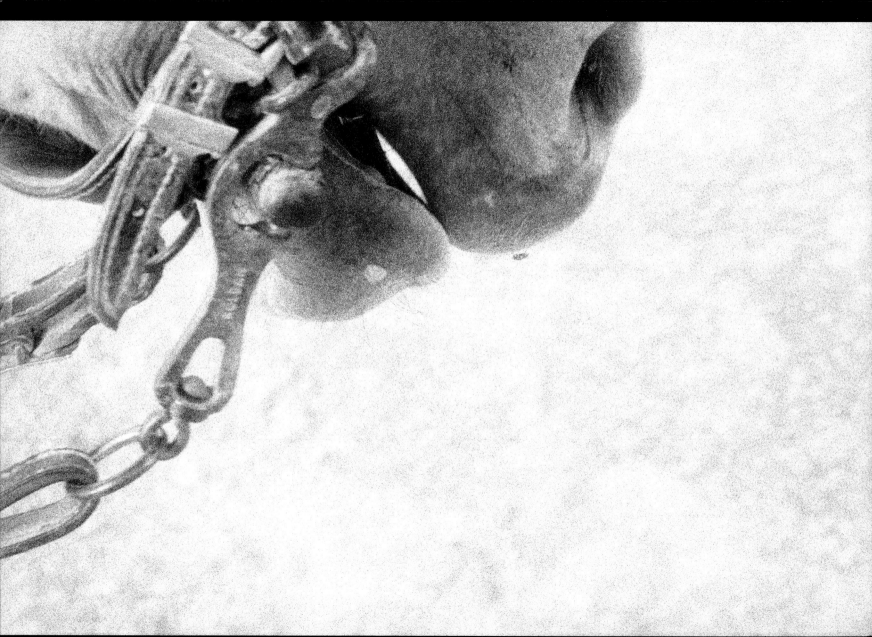

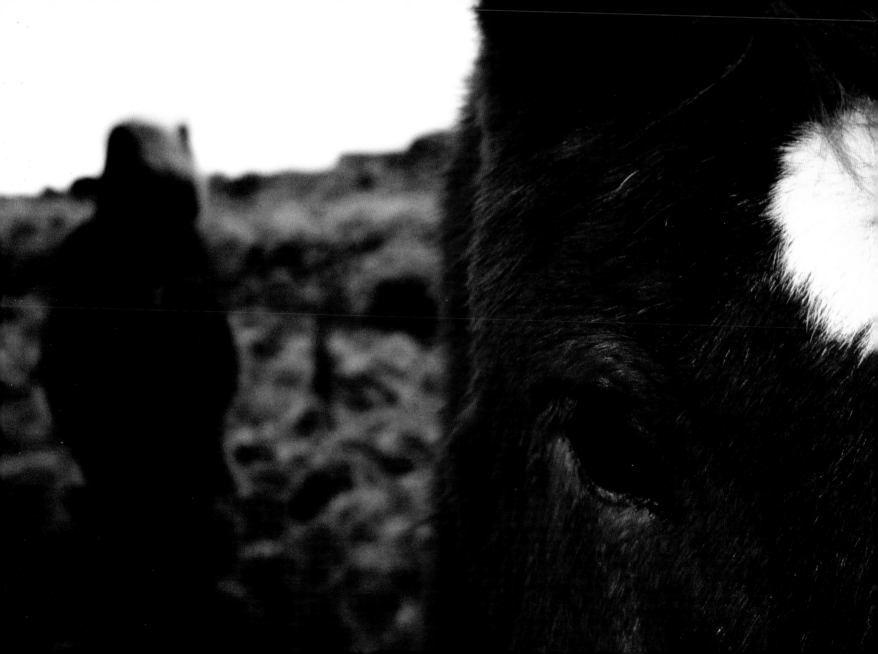

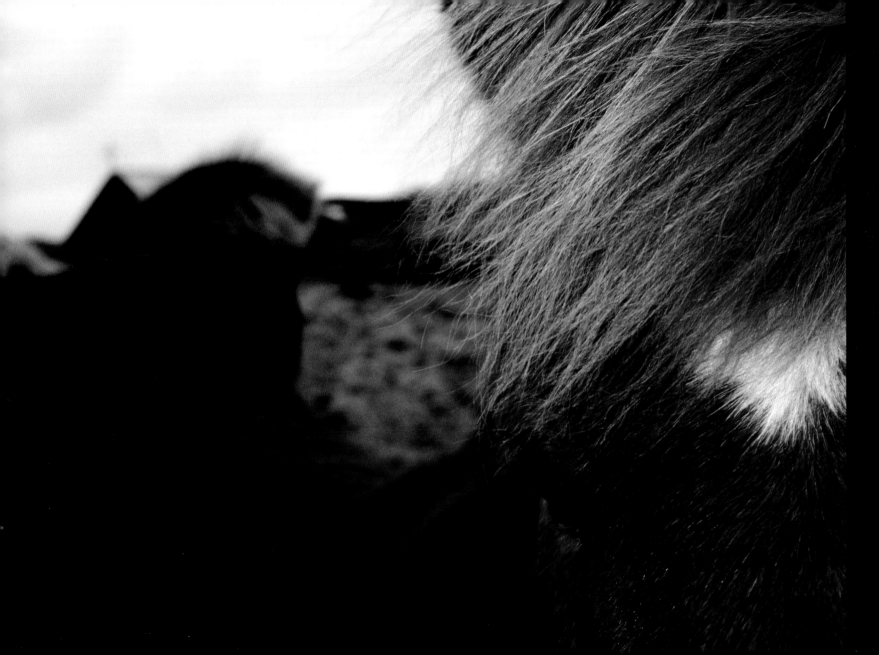

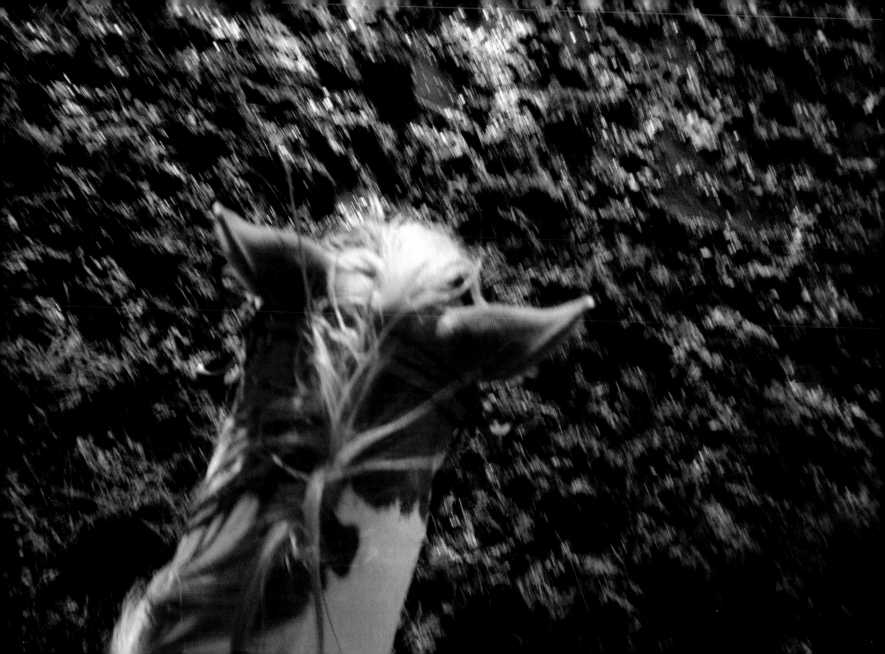

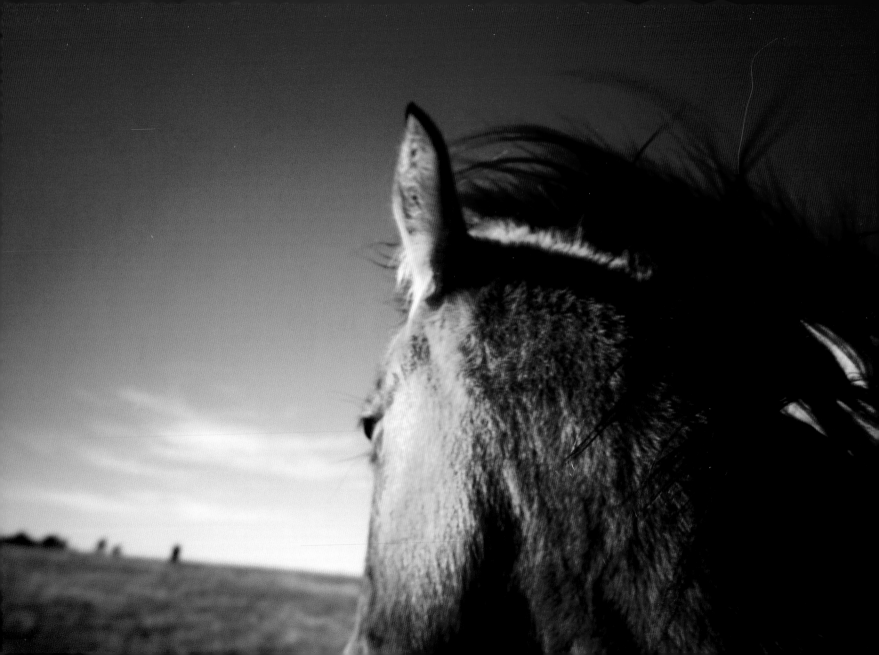

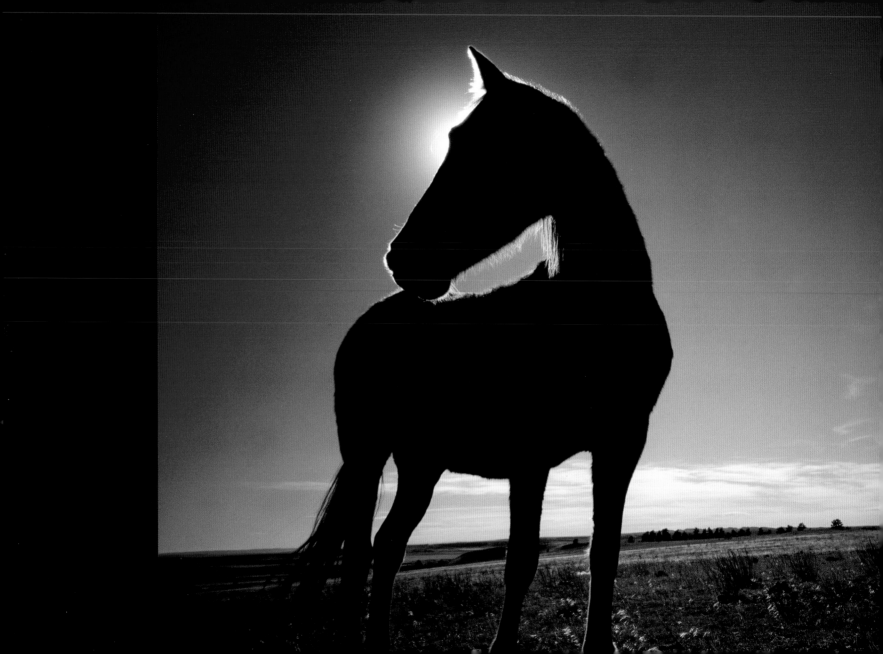

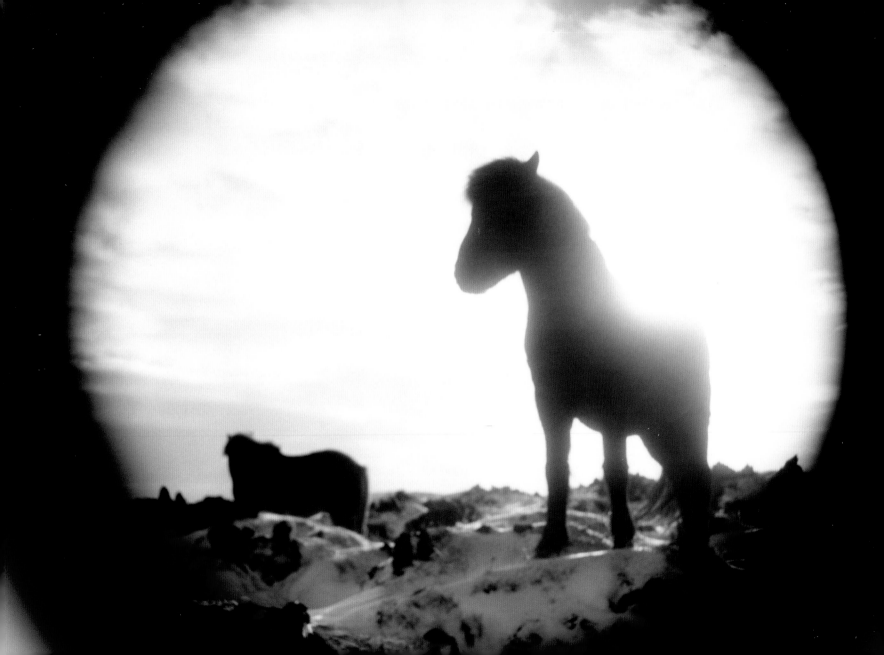

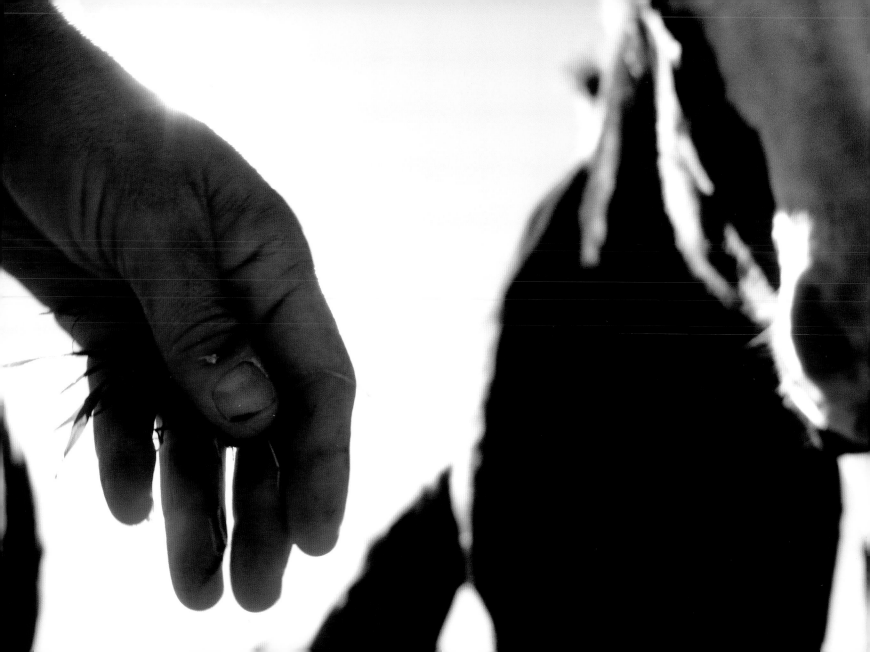

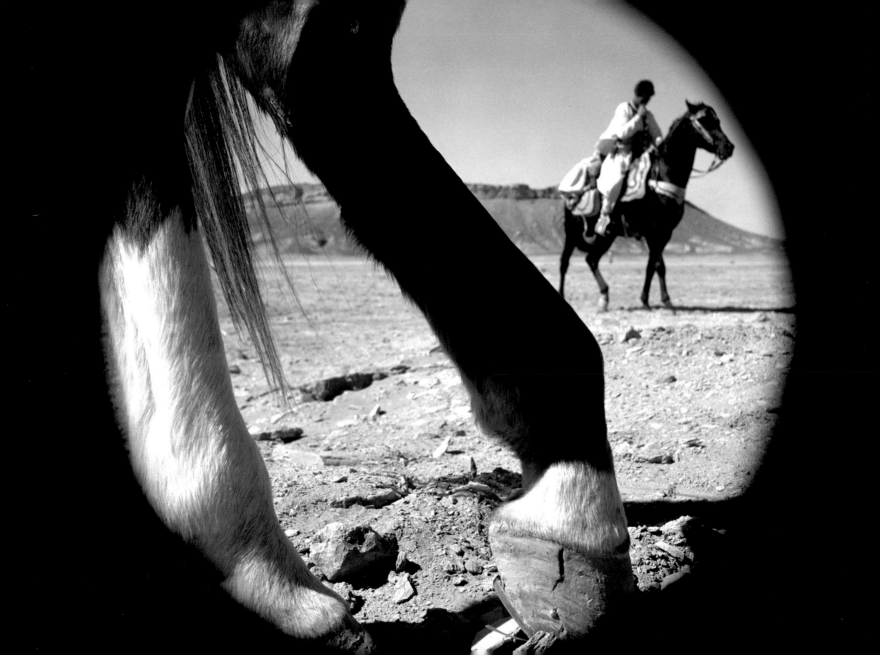

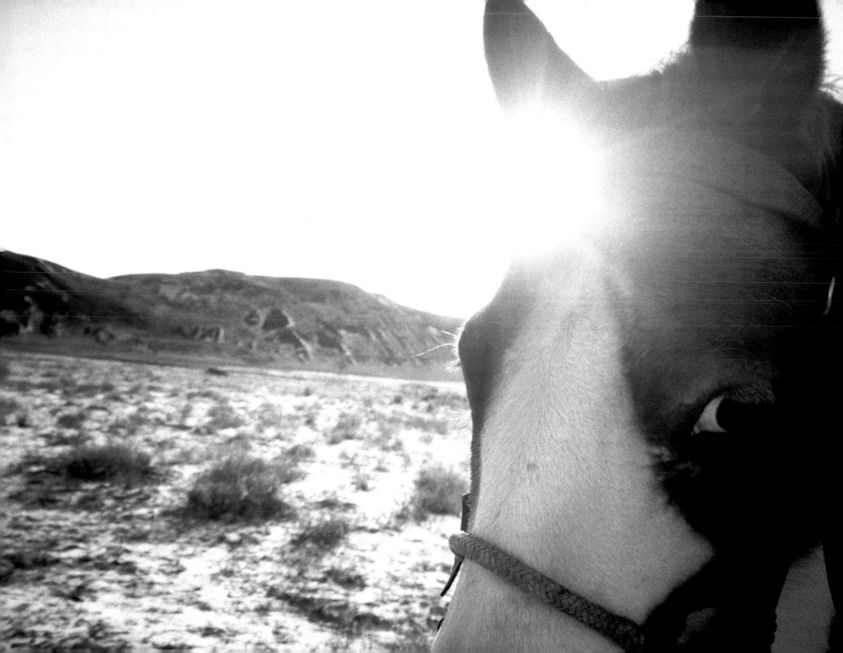

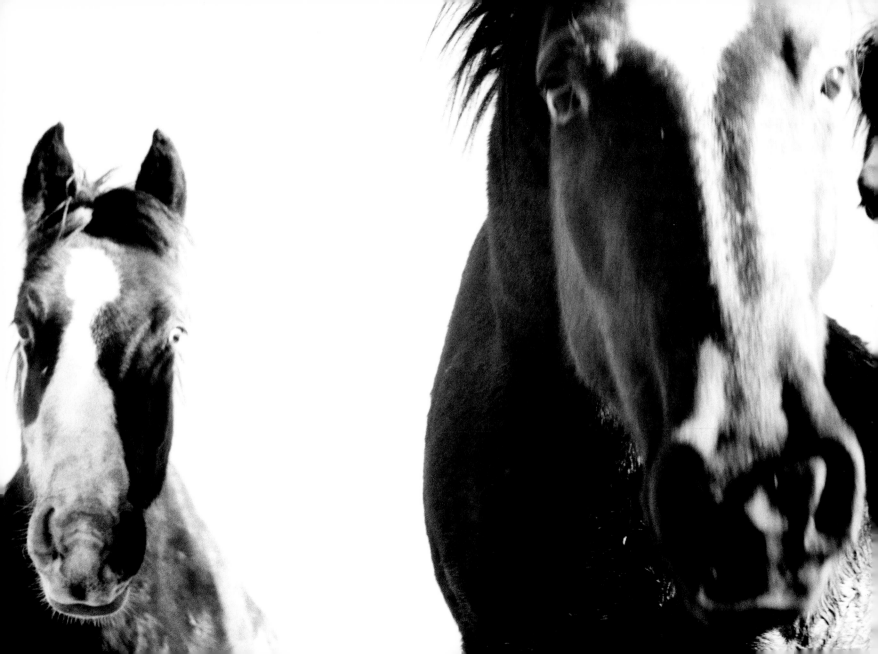

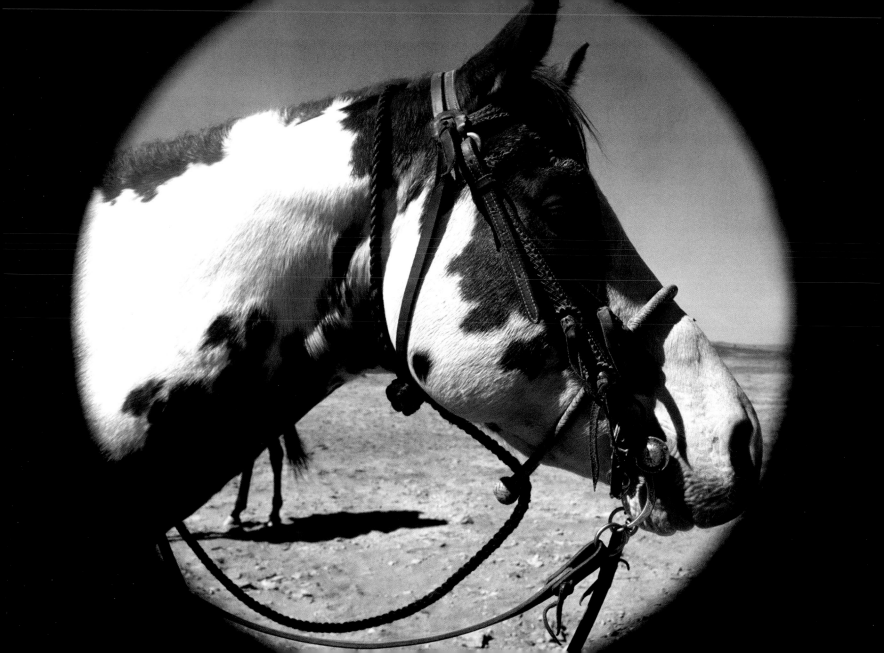

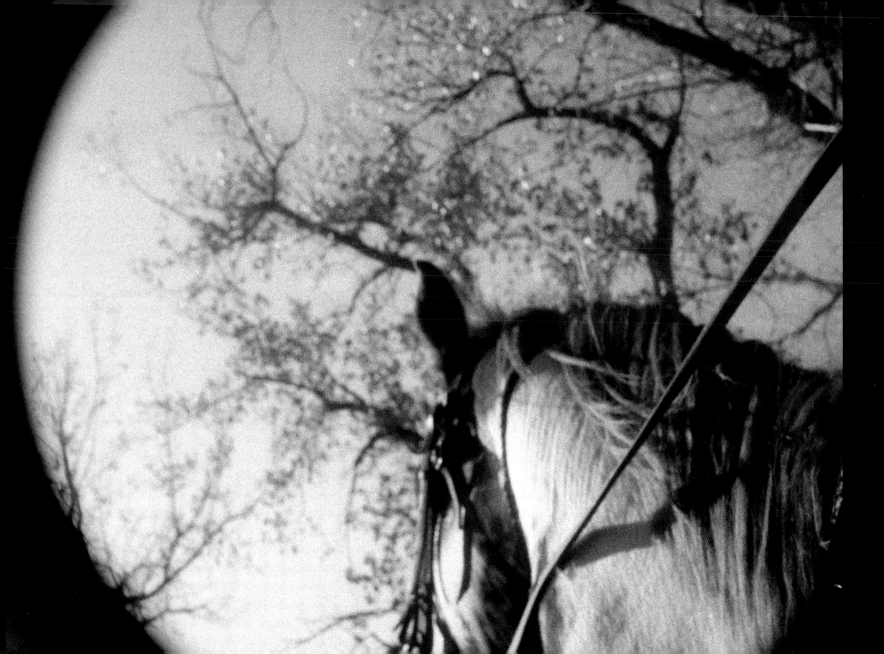

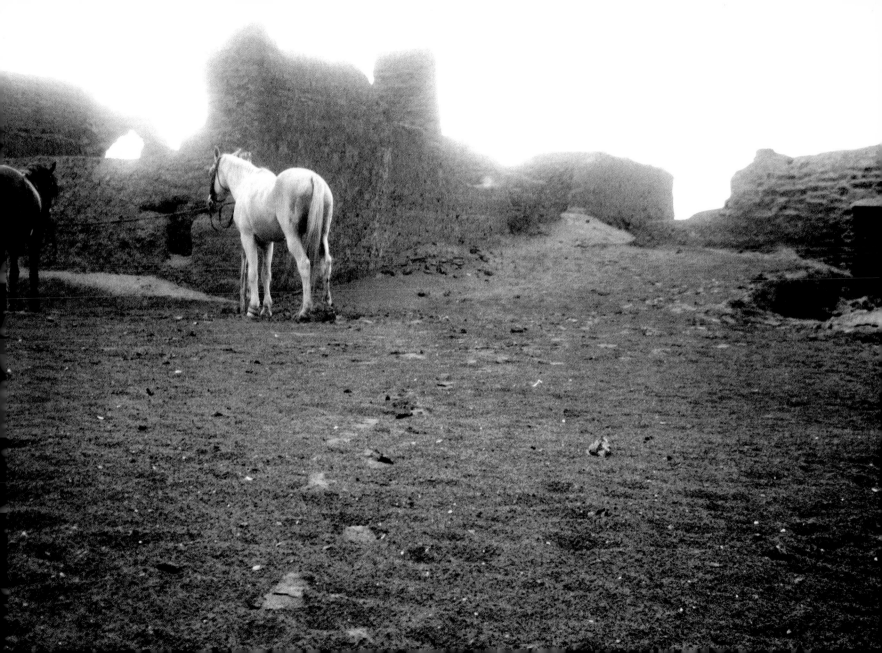

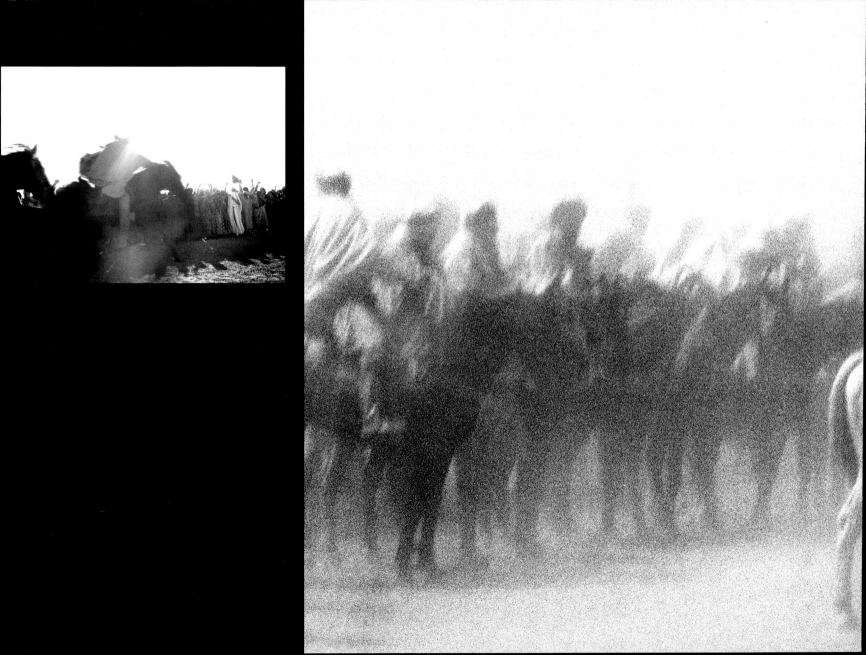

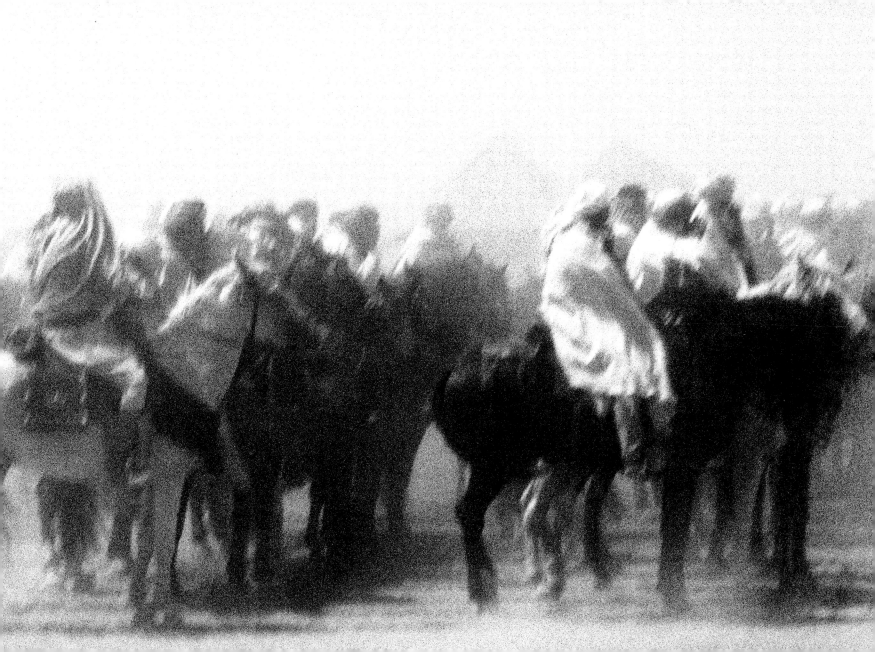

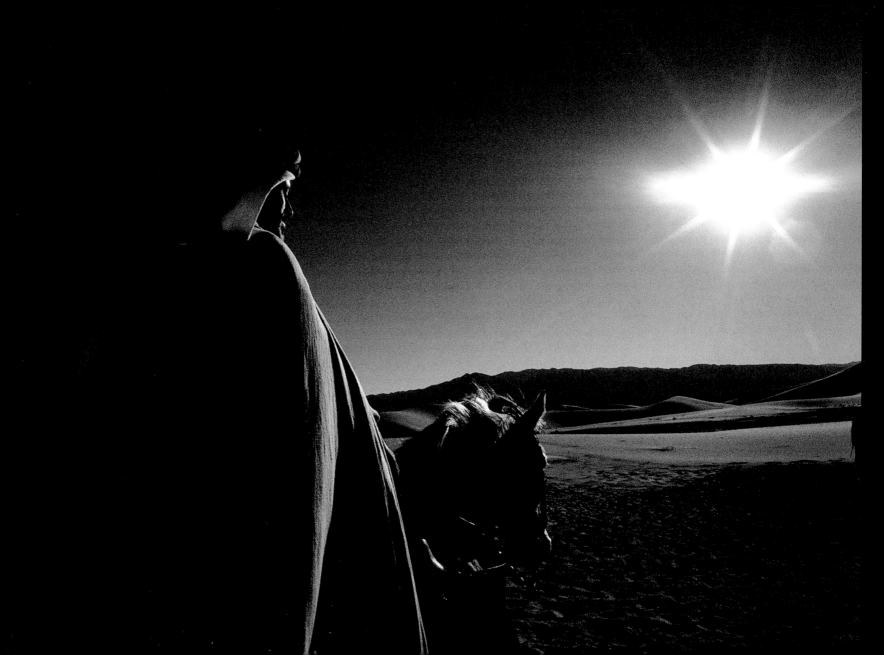

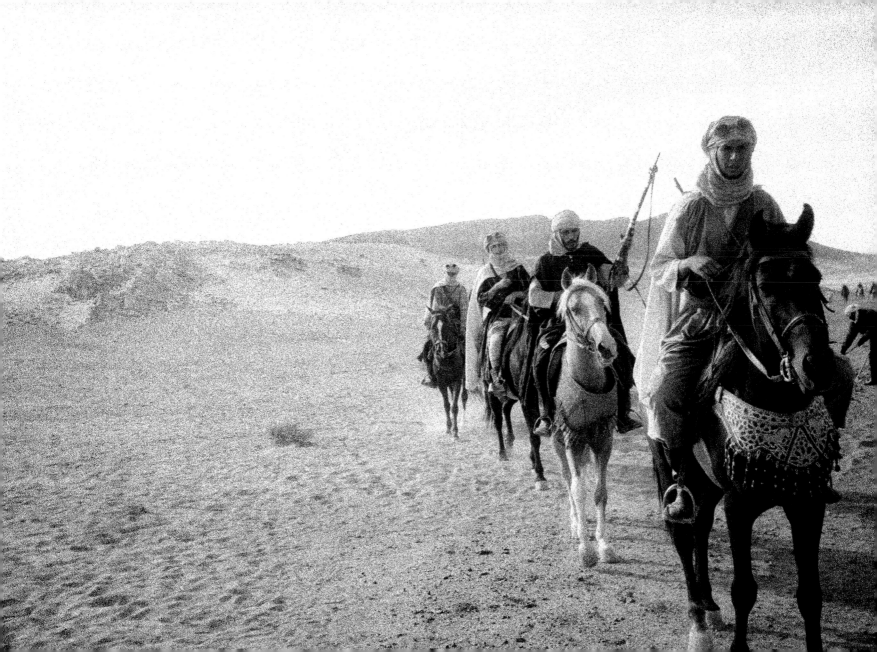

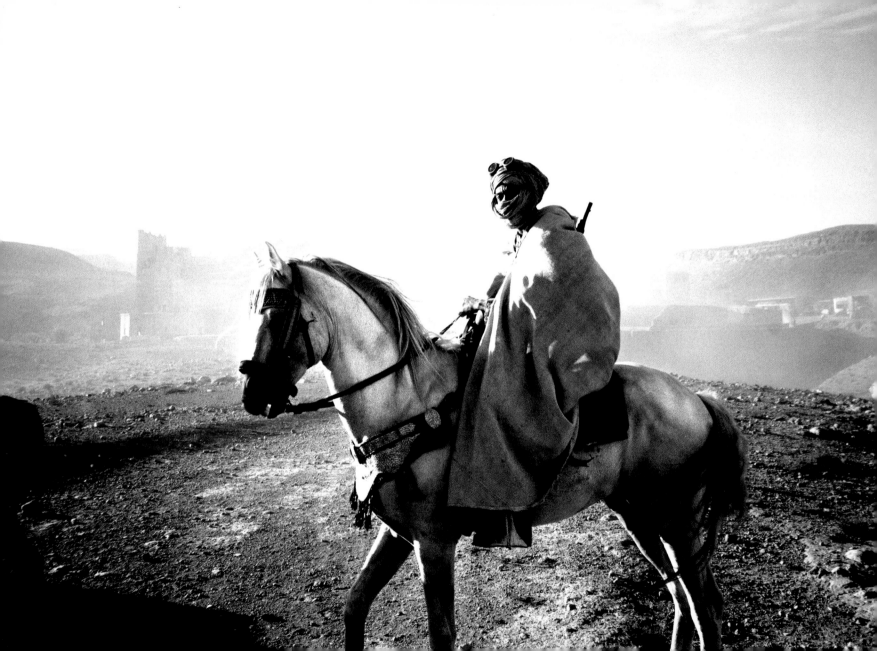

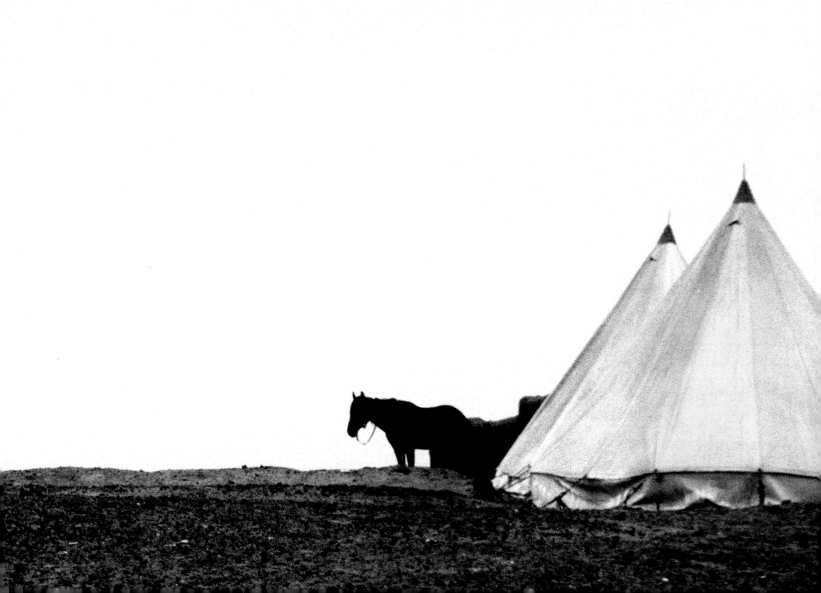

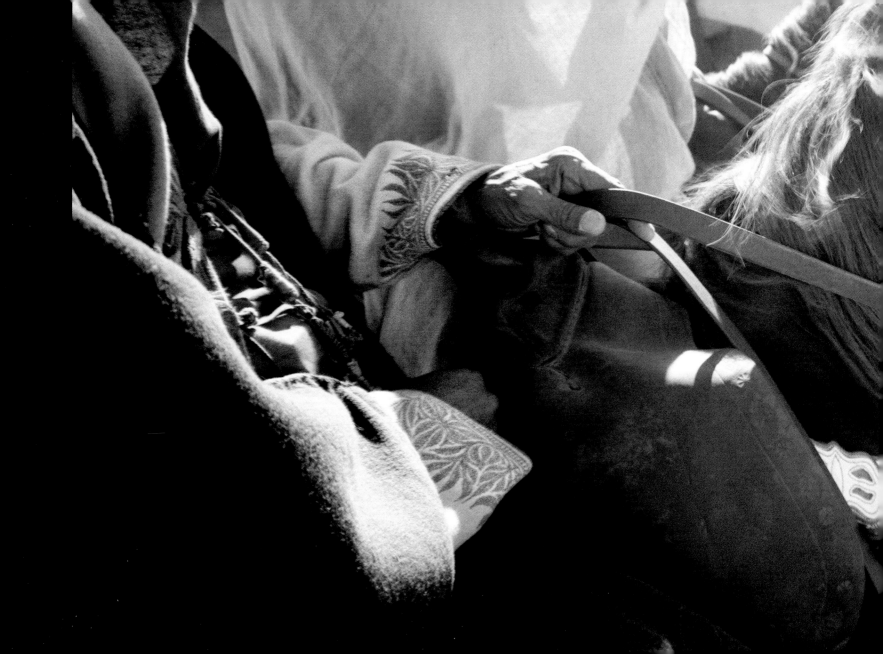

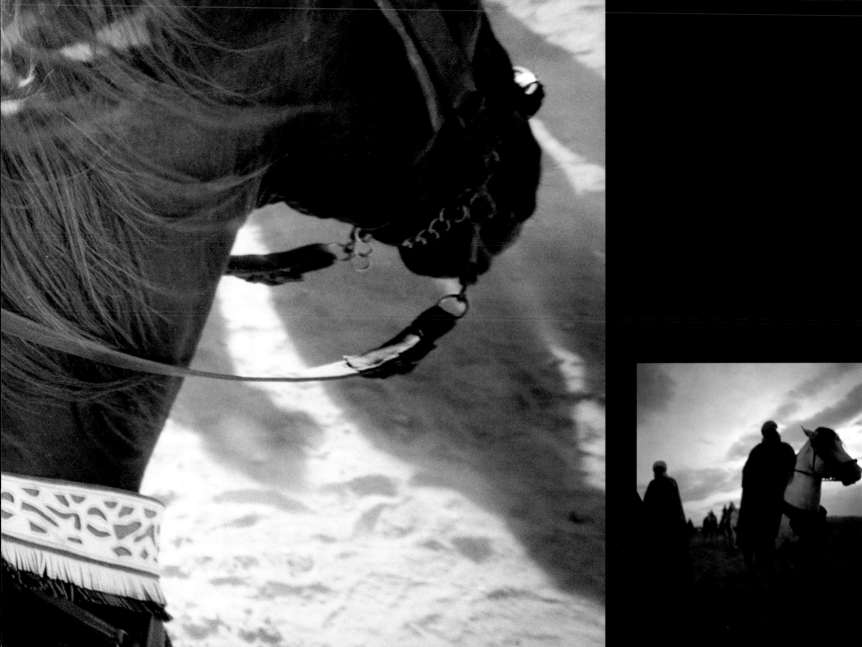

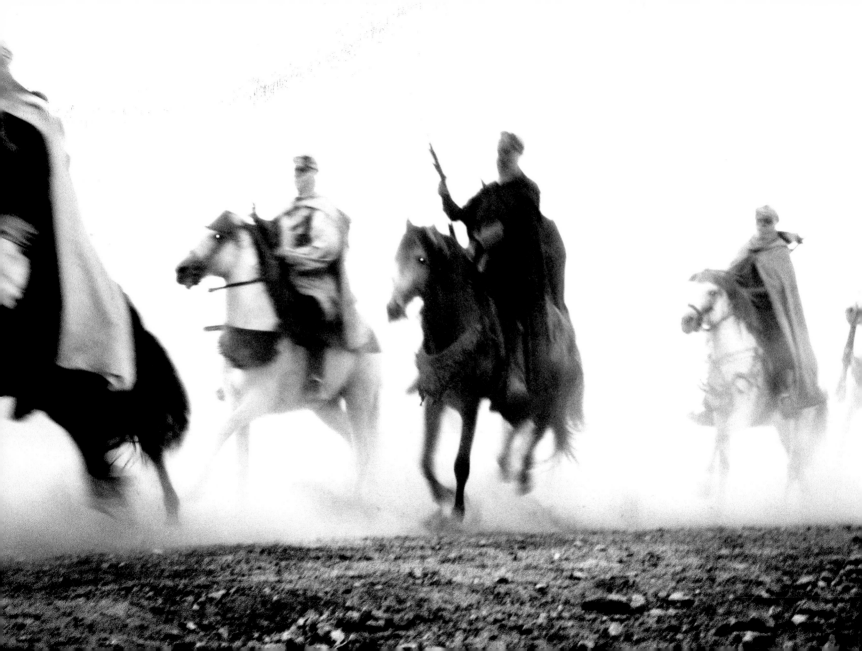

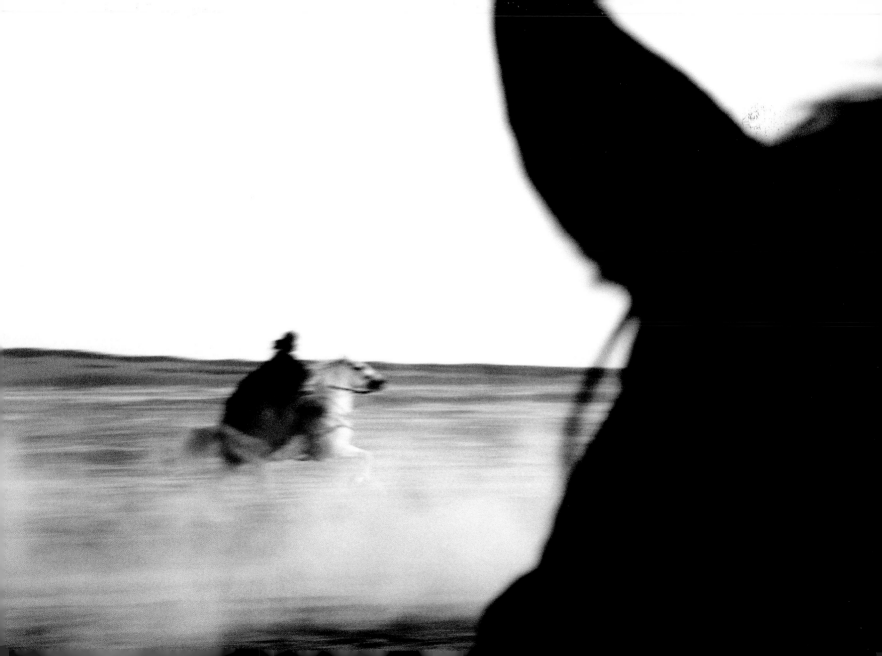

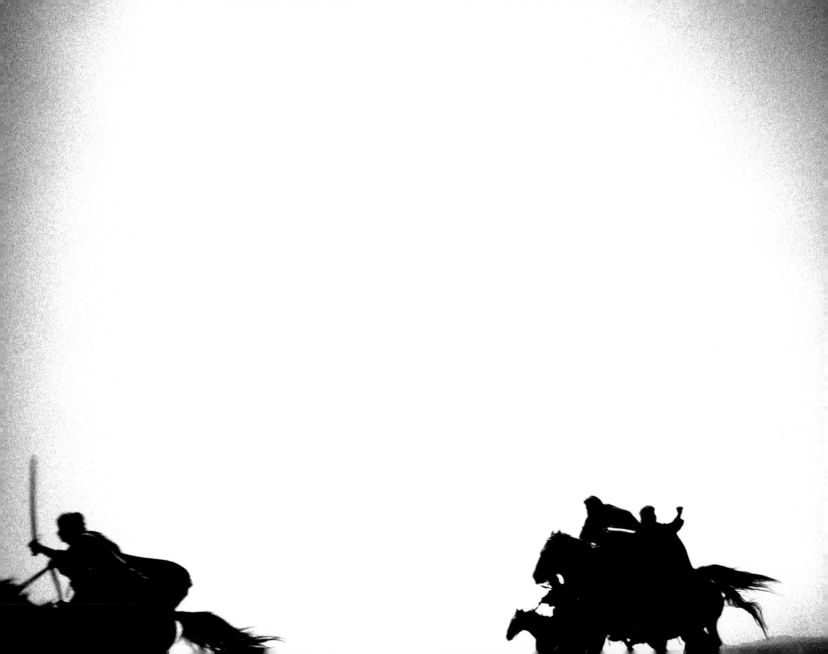

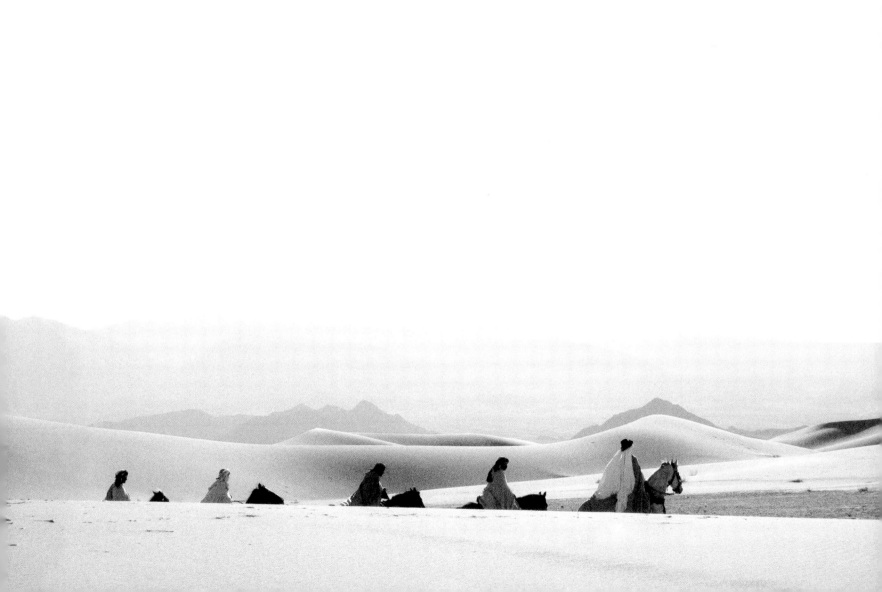

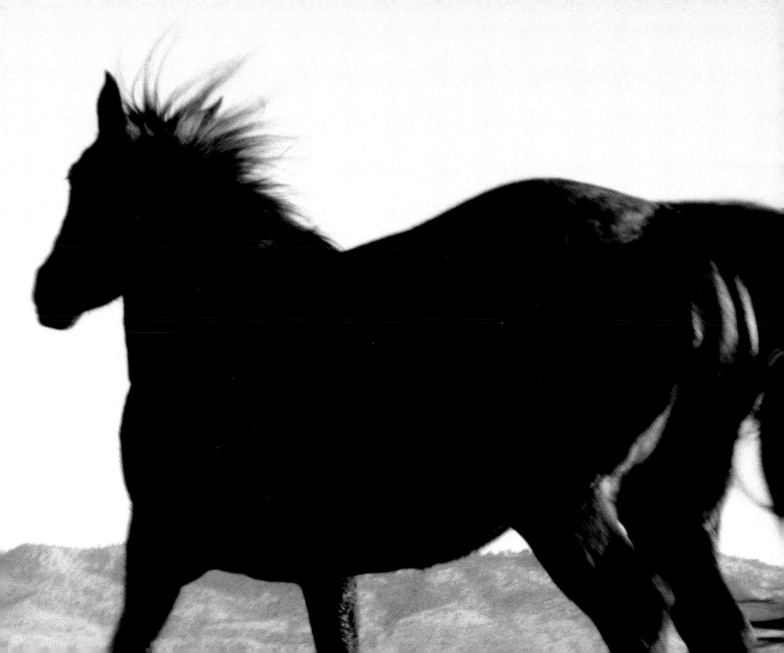

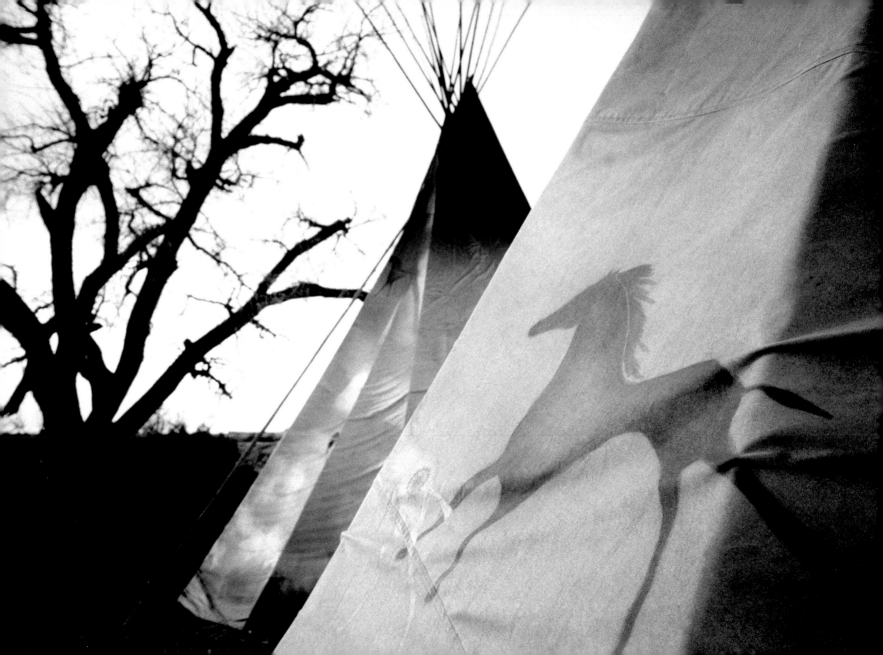

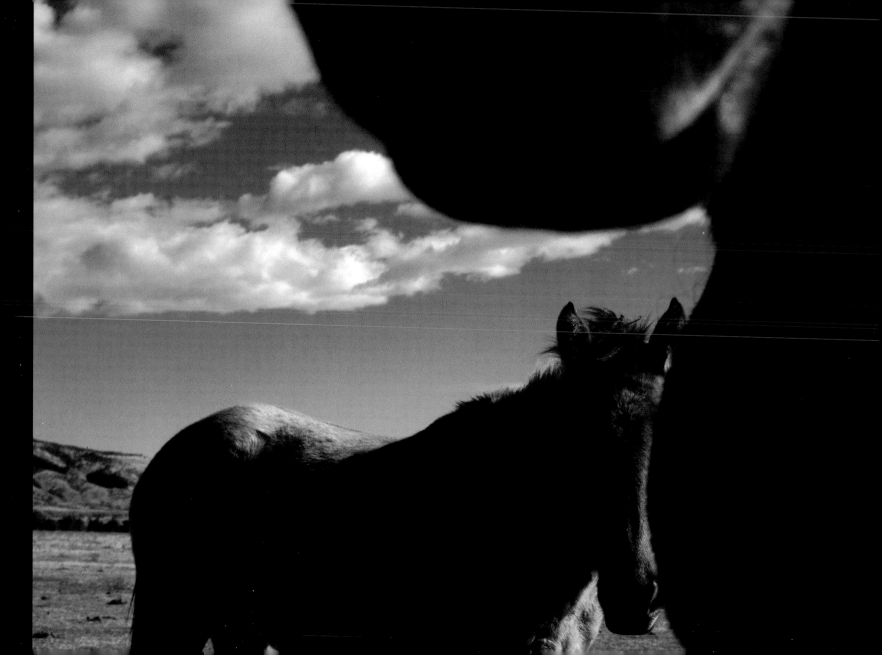

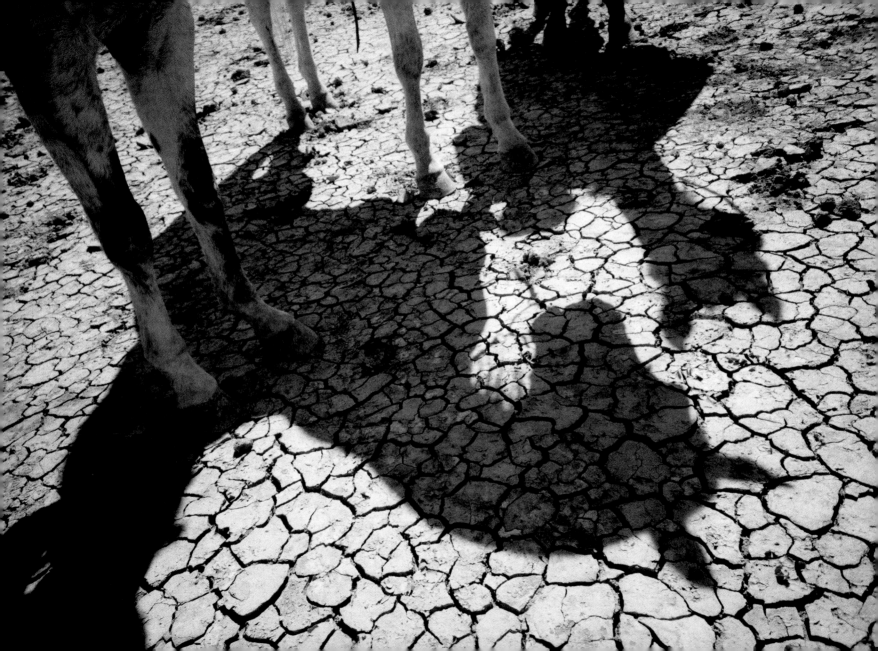

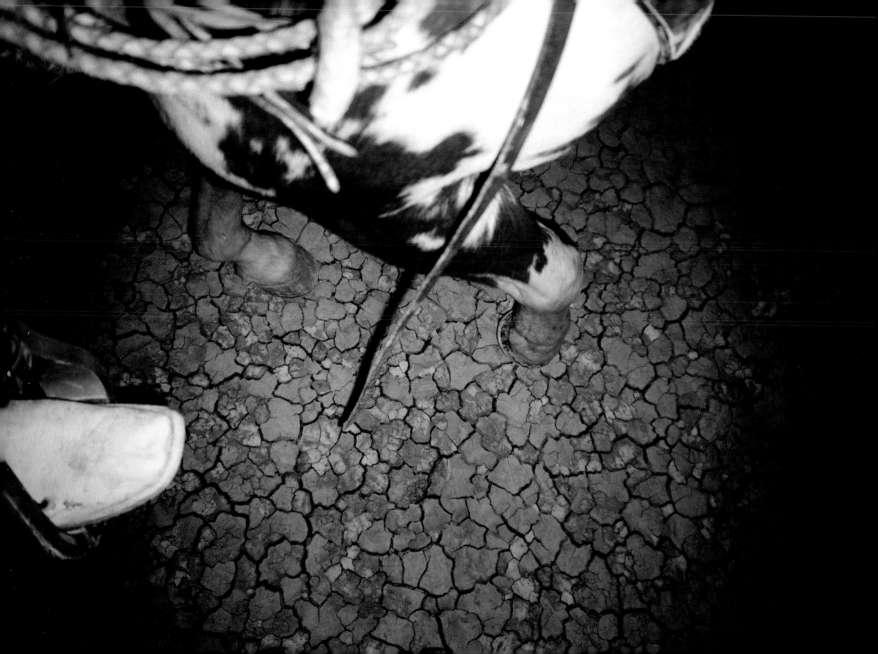

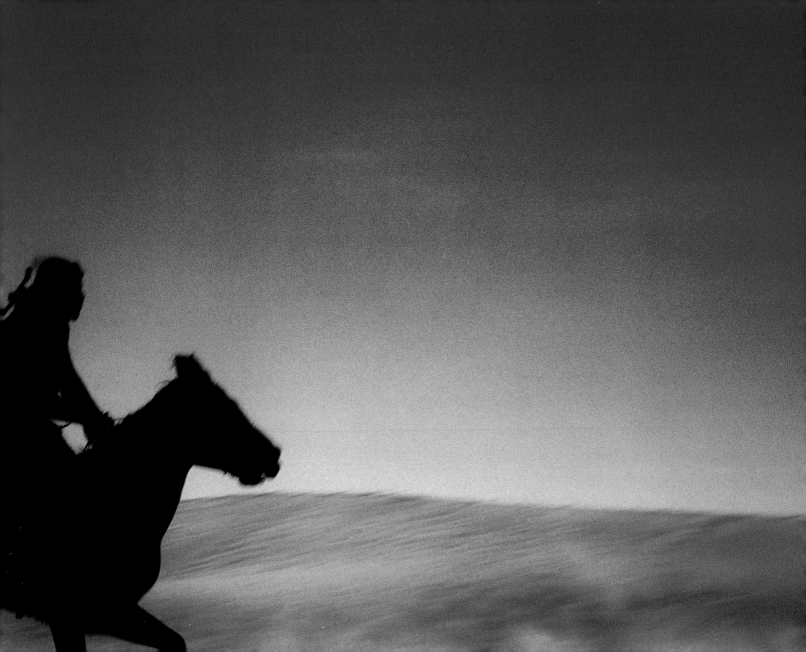

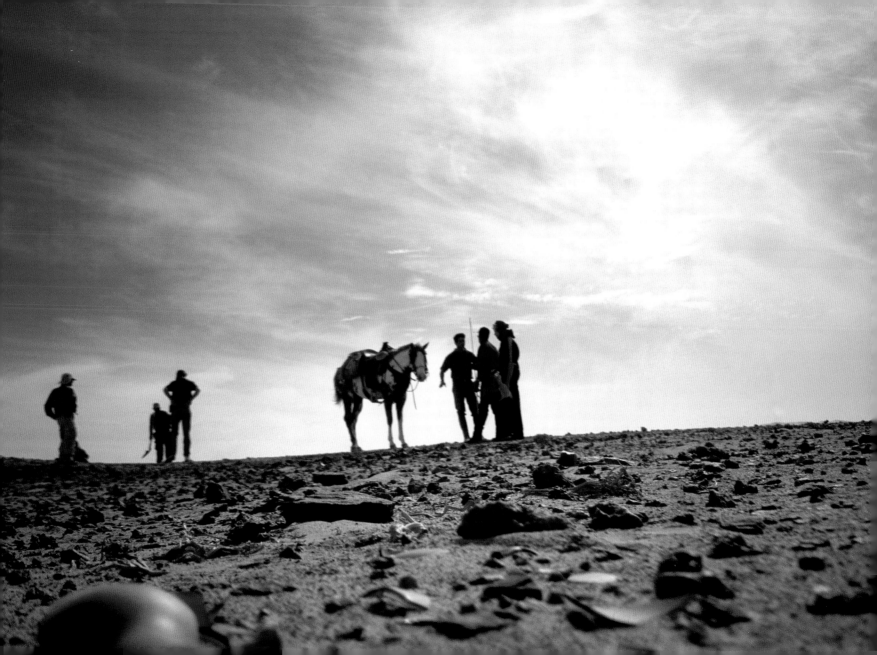

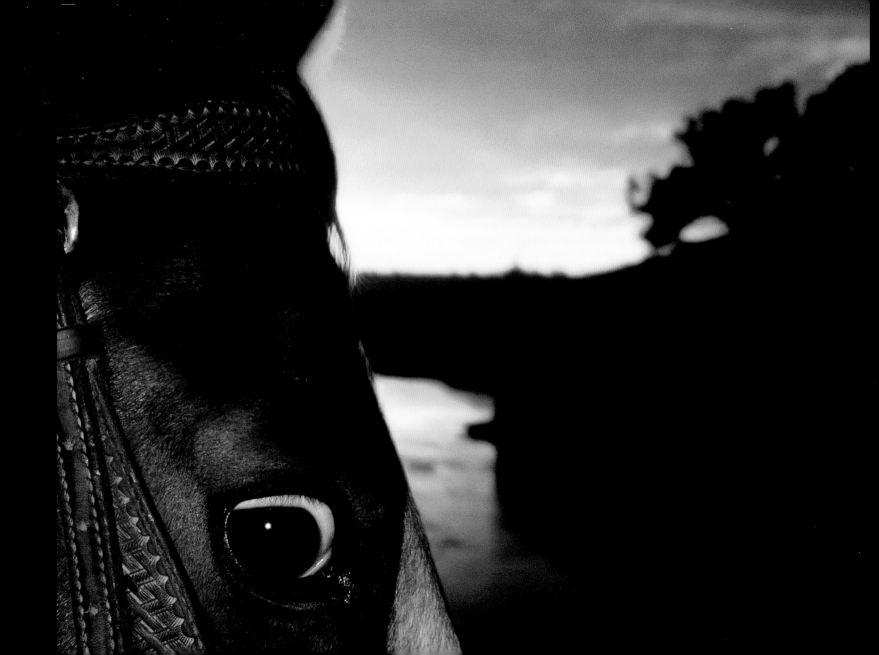

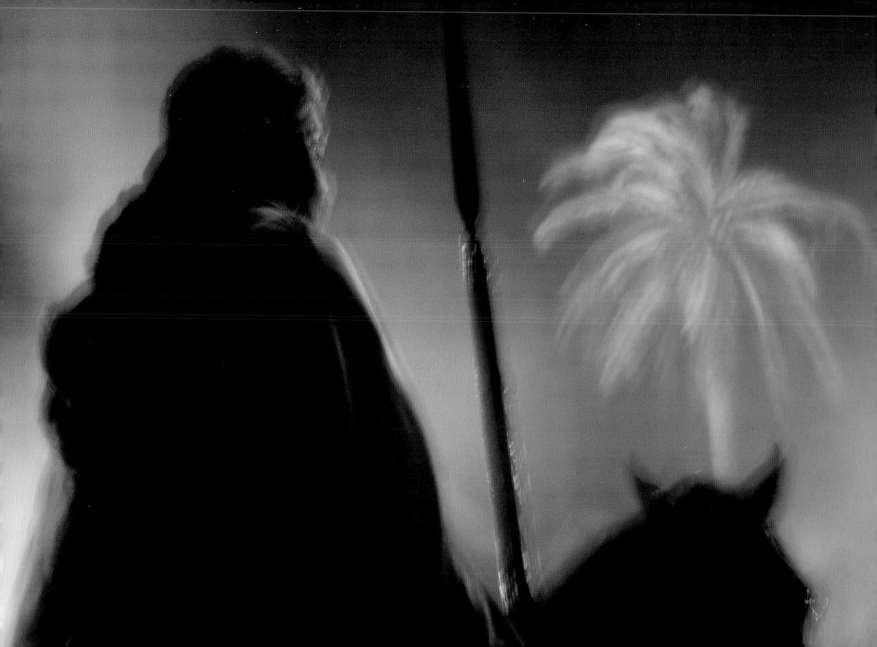

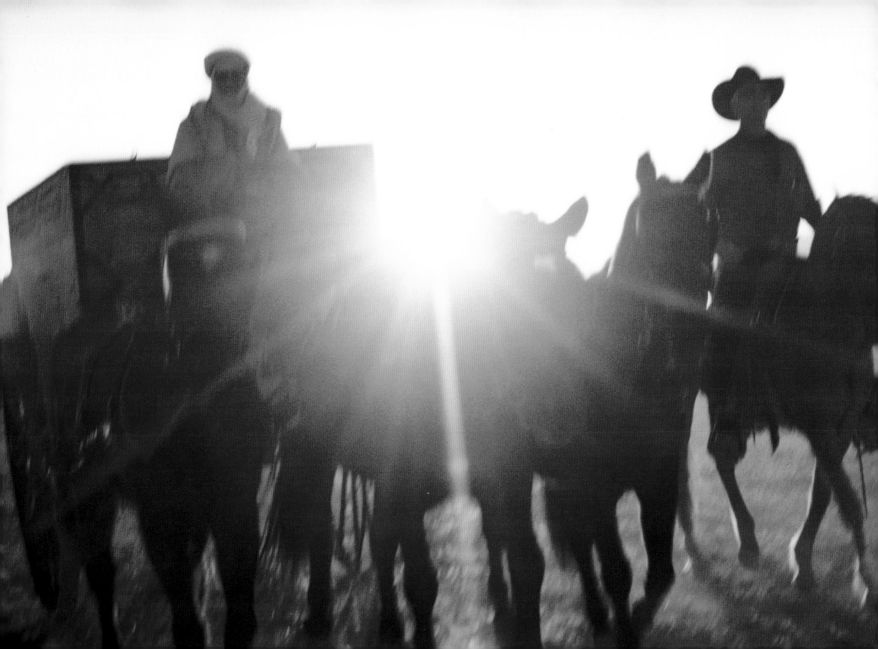

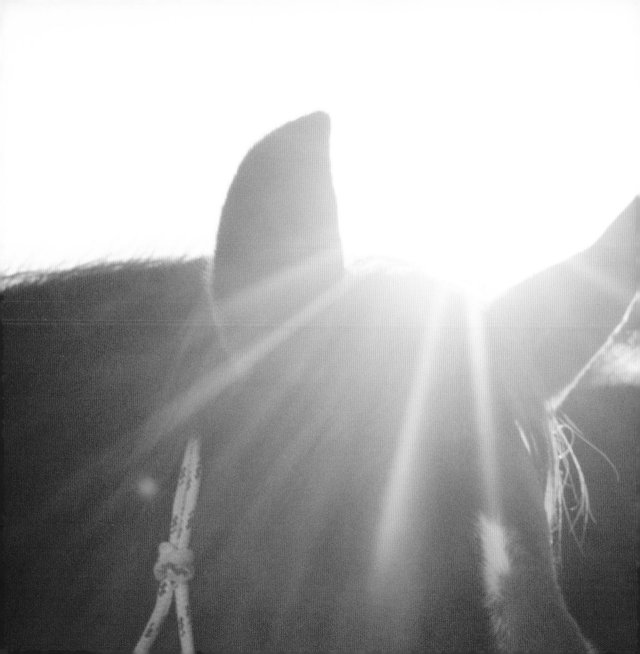

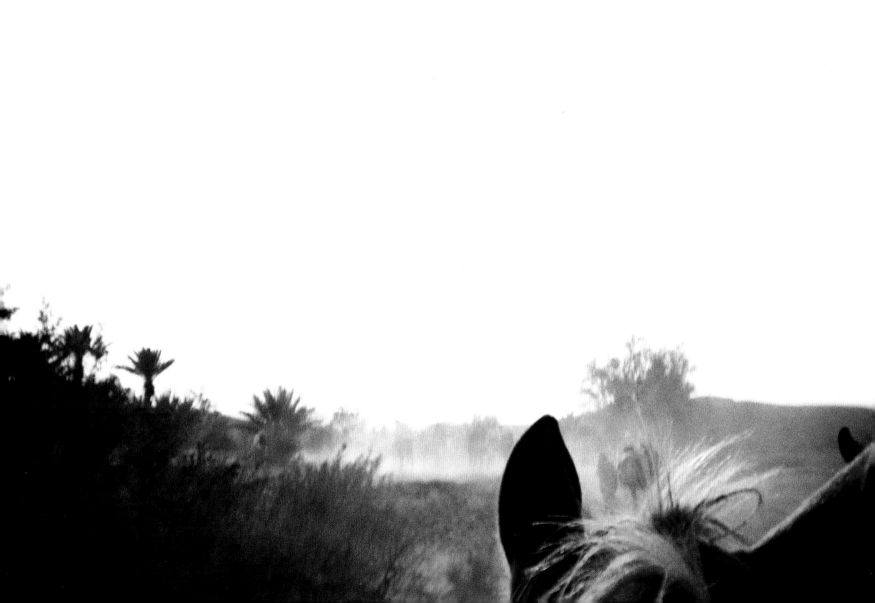

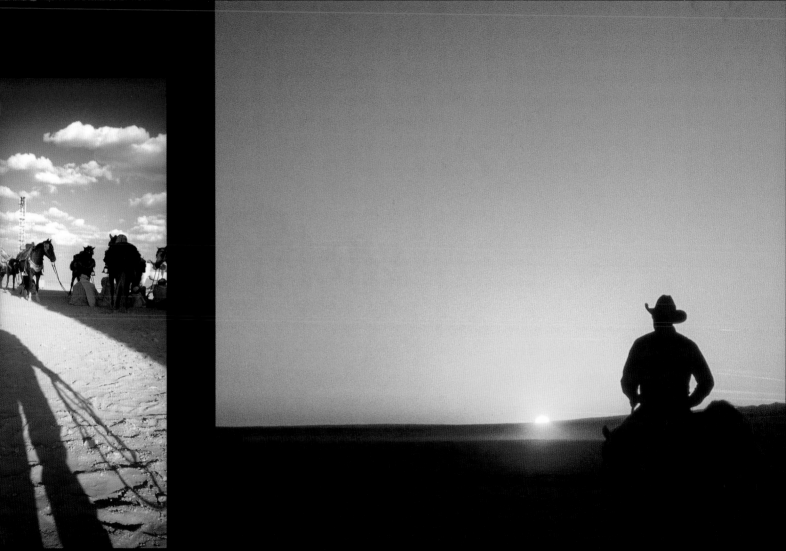

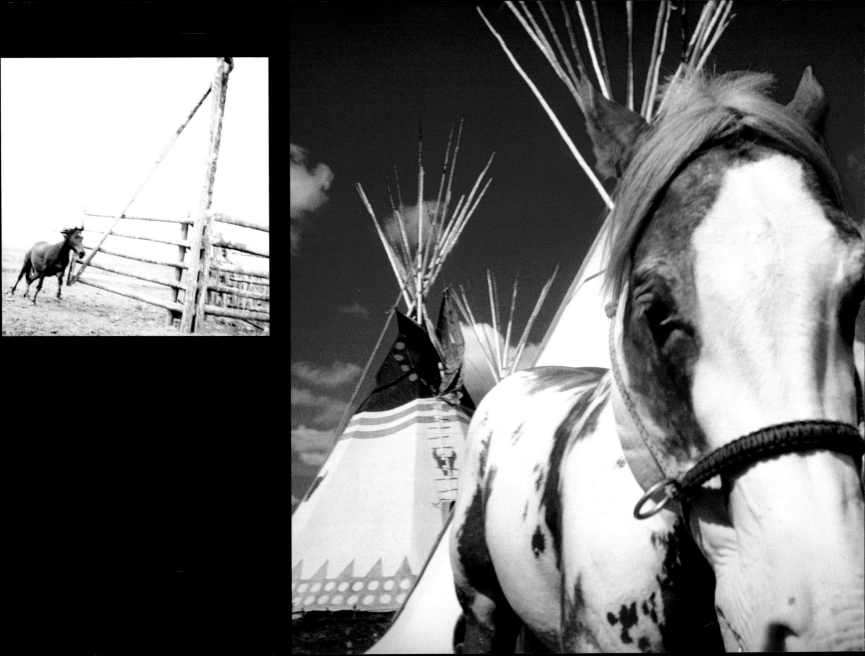

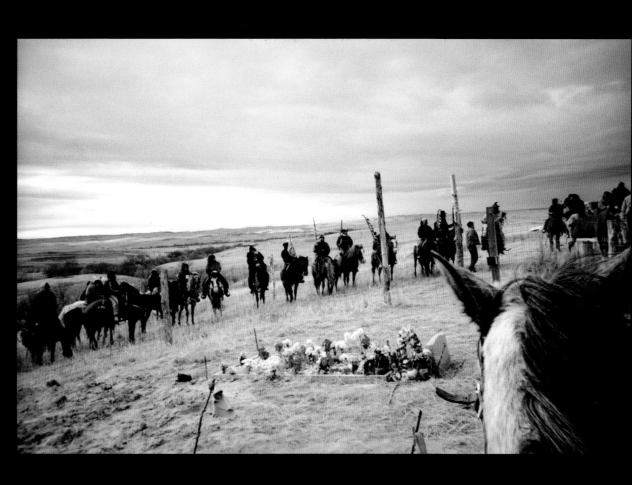

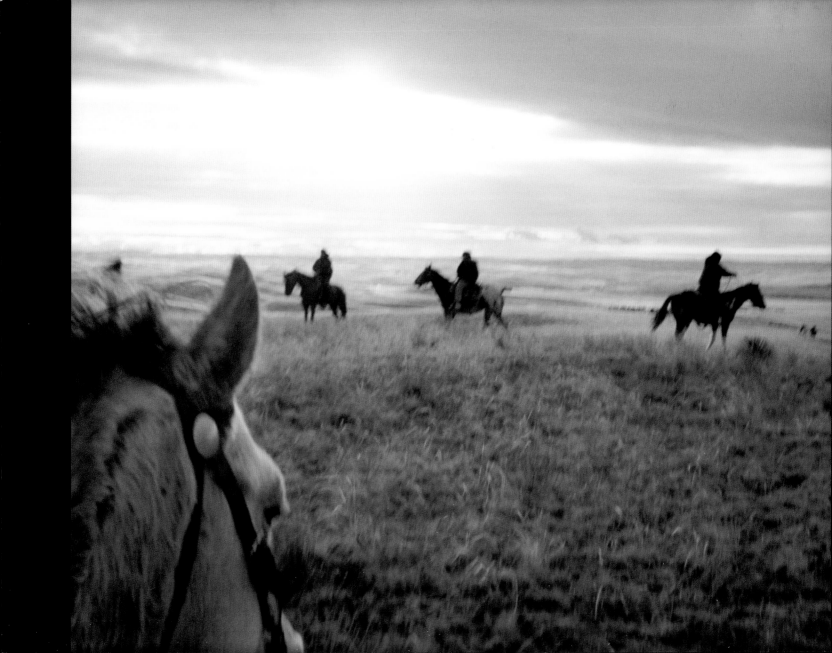

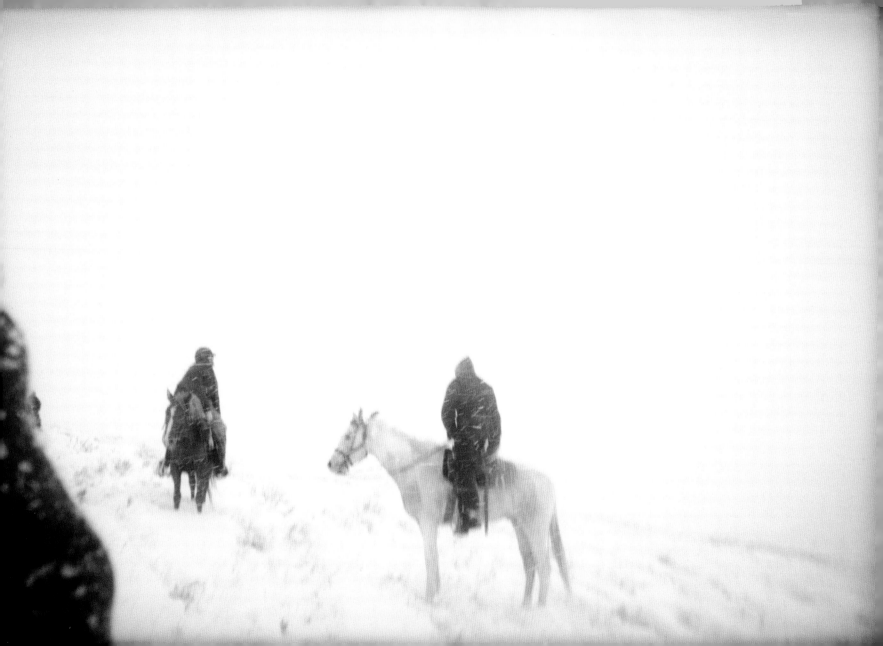

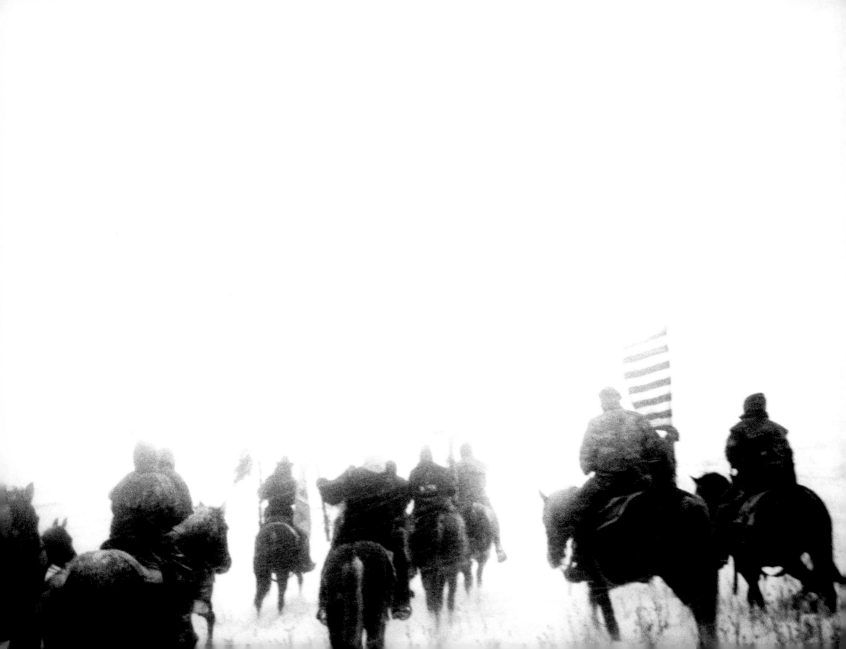

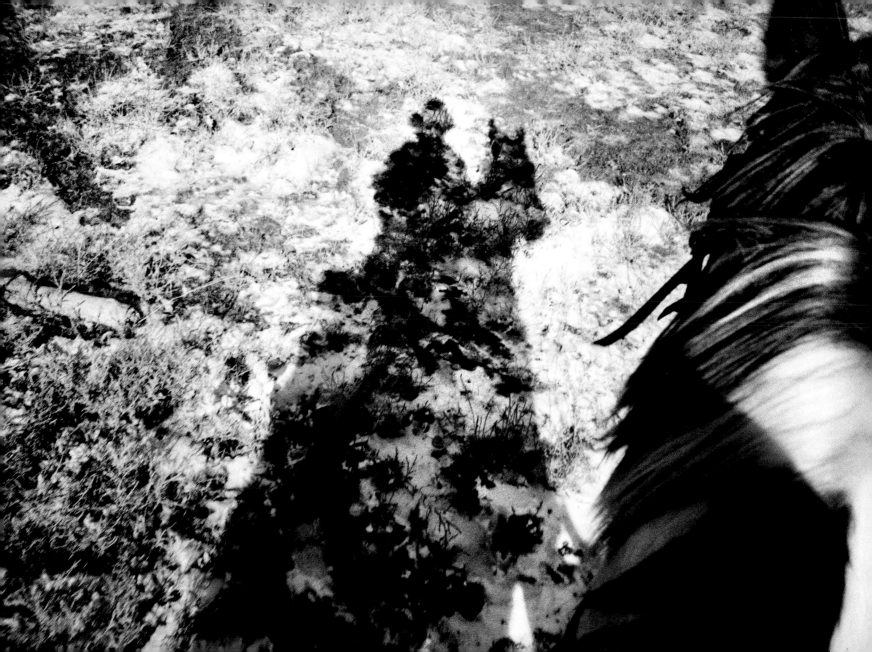

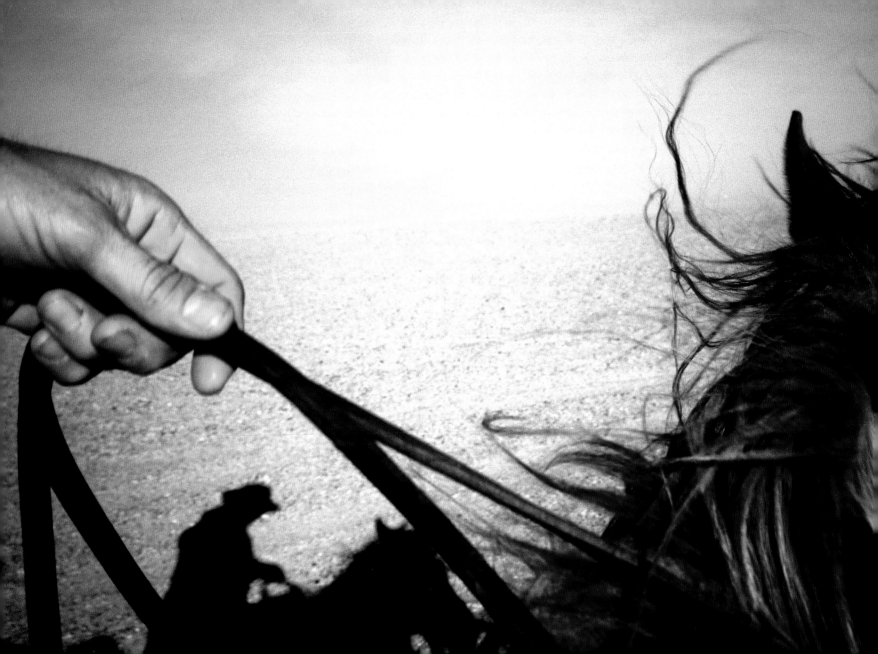

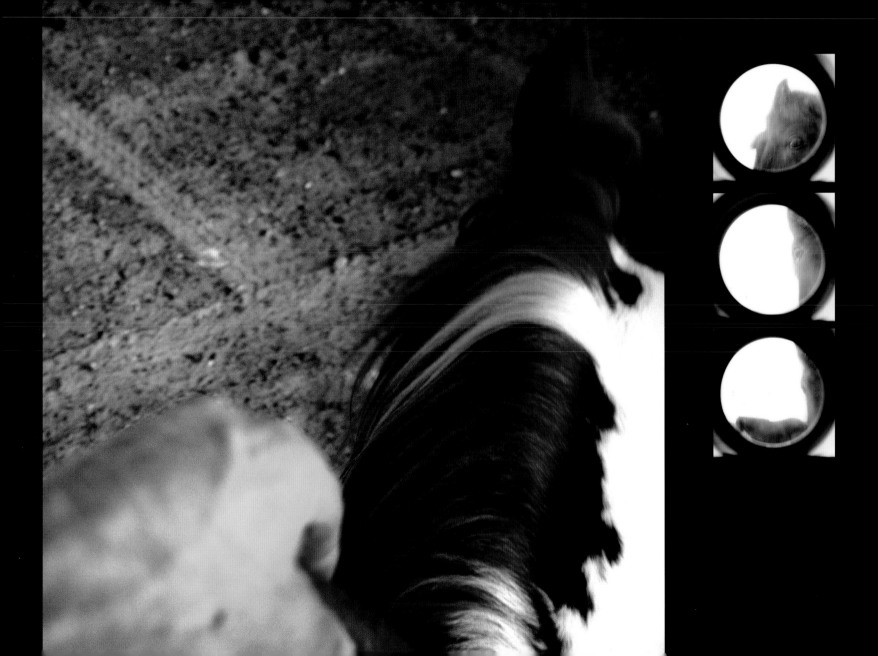

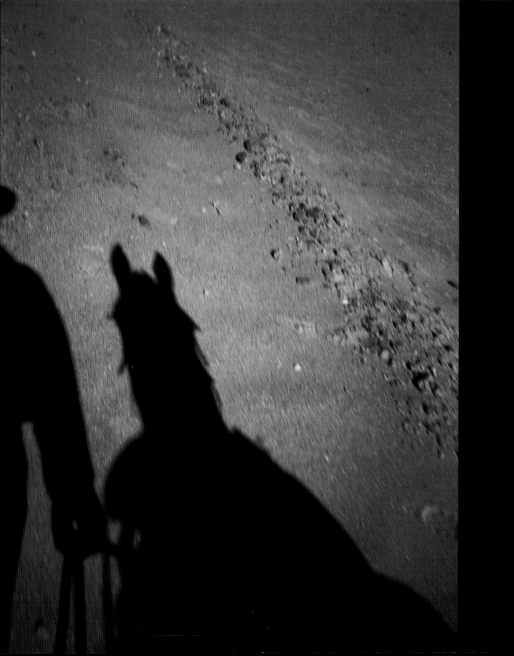

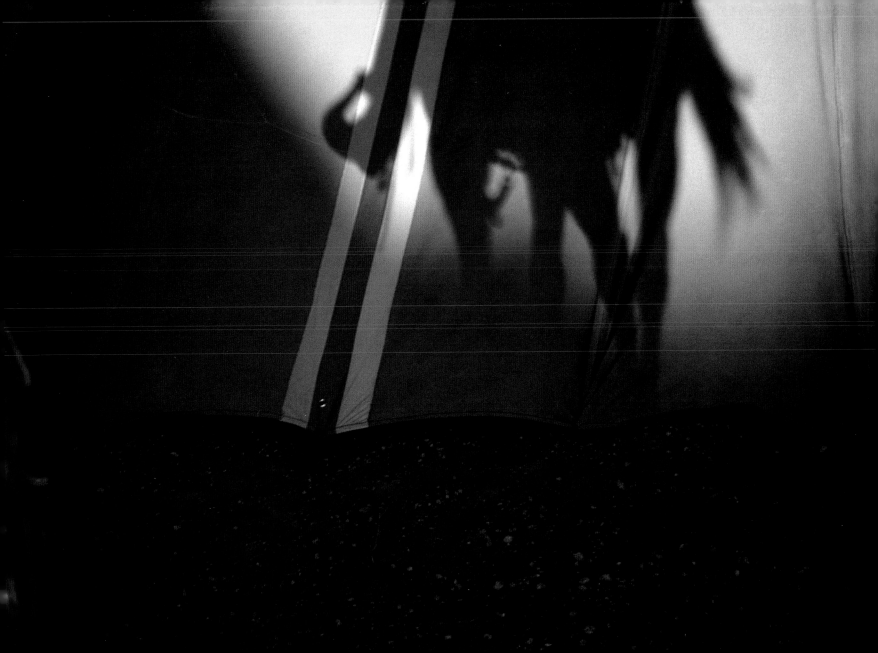

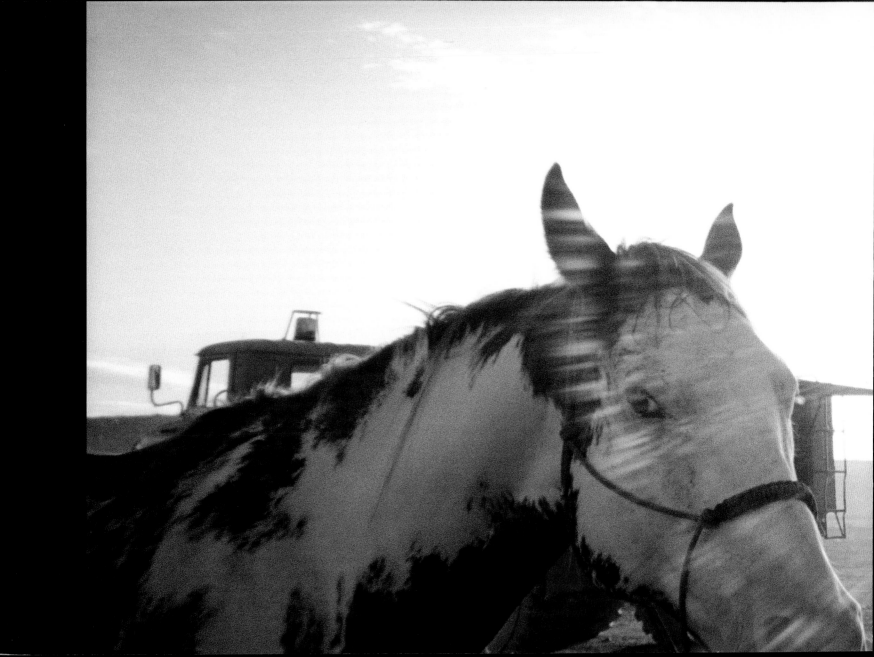

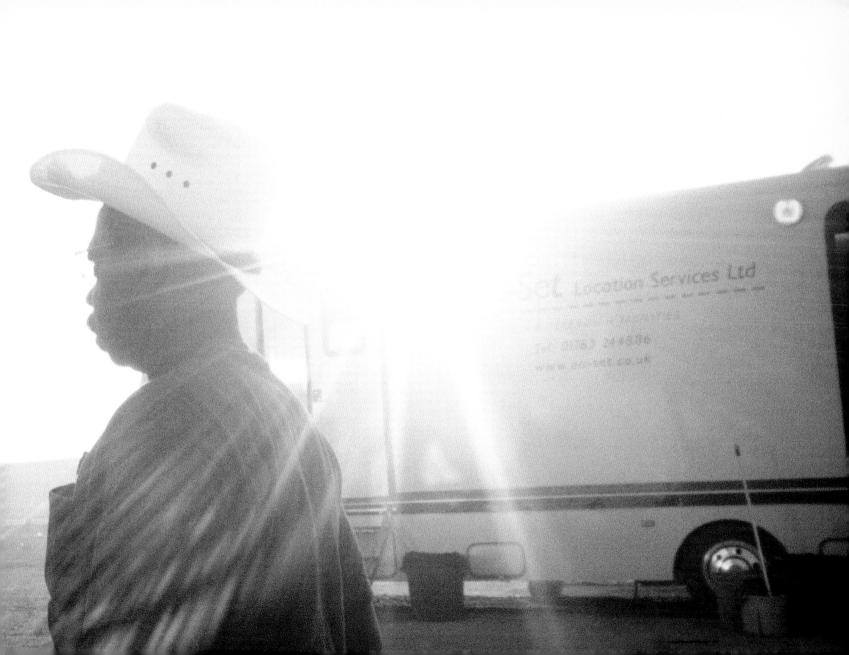

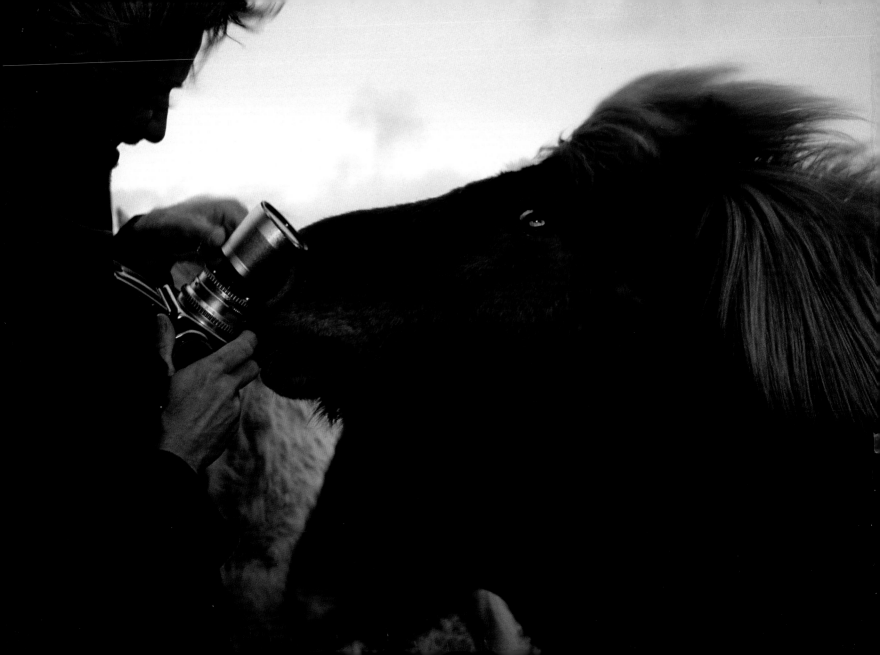

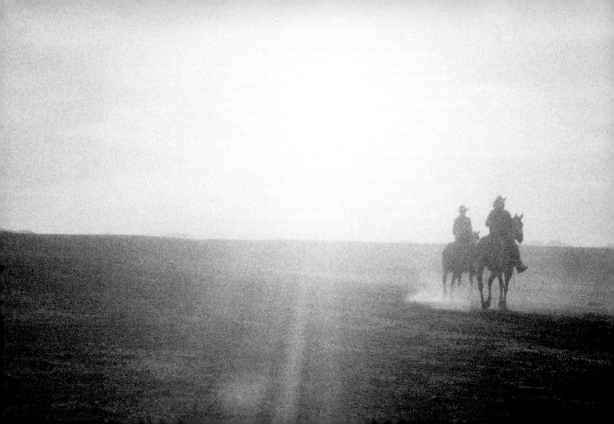